Contents

Library of Congress Cataloging-in-Publication Data The heritage village collection. New England village
series. p. cm. ISBN 0-86573-851-3 1. Cross-stitch--Patterns. 2. Villages in art. I. Cy DeCosse Incorporated.
TT778.C76H54 1996 746.46'041--dc20 96-18893

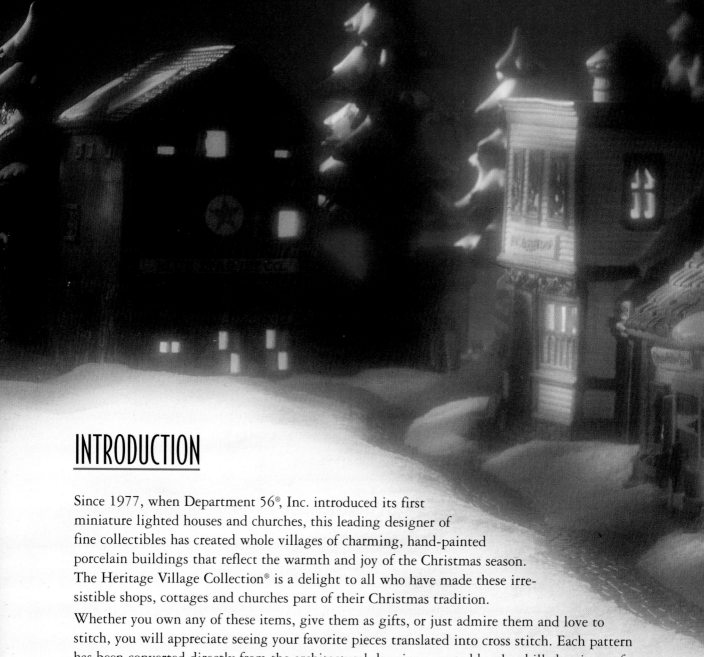

INTRODUCTION

Since 1977, when Department 56®, Inc. introduced its first
miniature lighted houses and churches, this leading designer of
fine collectibles has created whole villages of charming, hand-painted
porcelain buildings that reflect the warmth and joy of the Christmas season.
The Heritage Village Collection® is a delight to all who have made these irre-
sistible shops, cottages and churches part of their Christmas tradition.

Whether you own any of these items, give them as gifts, or just admire them and love to
stitch, you will appreciate seeing your favorite pieces translated into cross stitch. Each pattern
has been converted directly from the architectural drawings created by the skilled artisans of
Department 56.

The fifteen patterns presented here were selected from over forty New England Village® buildings
issued from 1986 to the present. Each design evokes the rural, hard-working, neighborly feeling of
small-town America, and reflects the same extensive research and attention to detail found in all the
village groupings. In this nostalgic journey through the countryside, revisit the era of horse-drawn
sleighs, sturdy barns and farmhouses, mills and shops.

Whichever building you choose to begin with, use the box labeled *Personal Notes* to record a stitching
history for each pattern – when you began and finished it; the name of the recipient, if you made it as
a gift; and any stitching information you want to remember. Your stitched New England Village pieces
can decorate your home all year long, or become the beginning of a lovely new Christmas tradition for
you, your family and friends.

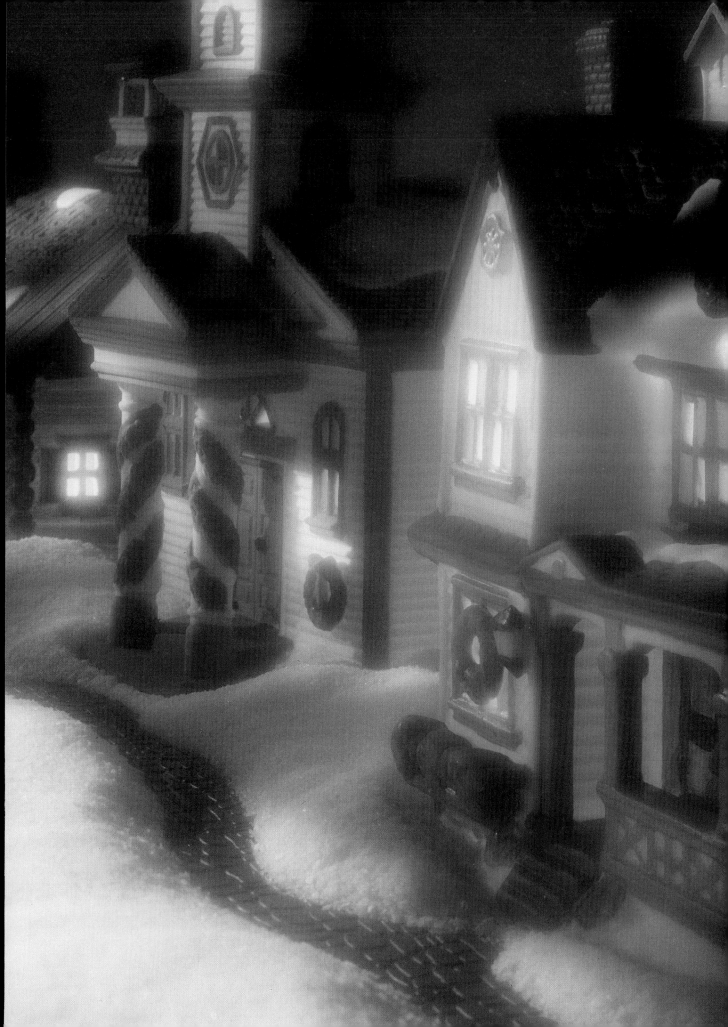

BLUEBIRD SEED AND BULB

FINISHED DESIGN SIZE: 10 3/8" x 8 1/2"
FRAME SIZE: 19 1/2" x 18 1/4"

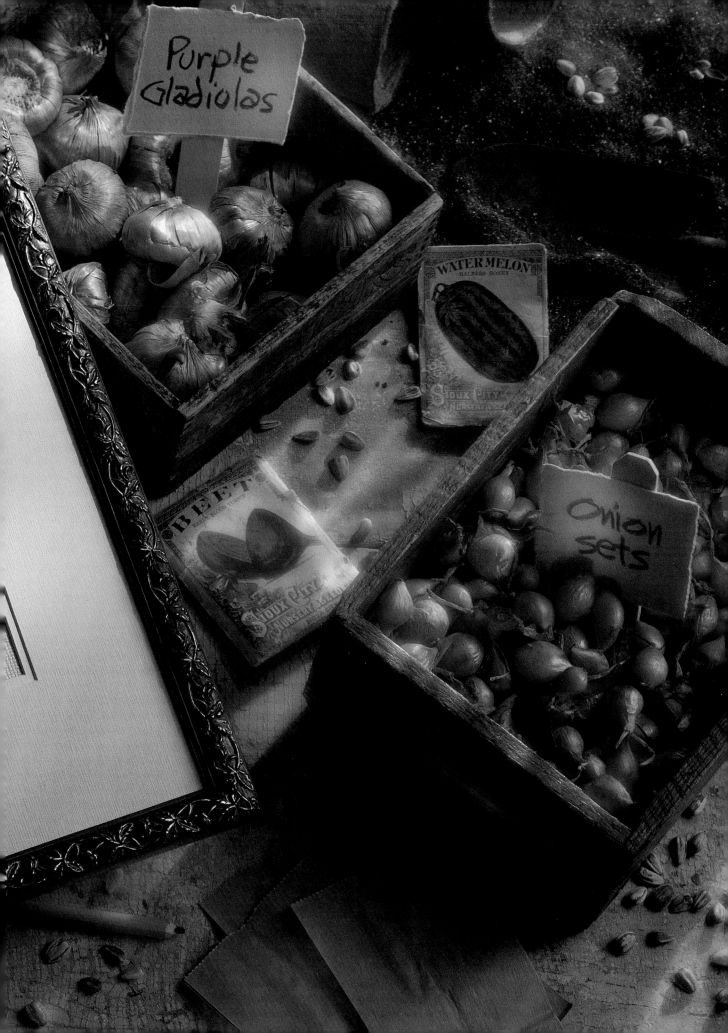

BLUEBIRD SEED AND BULB

ISSUED in 1992 CURRENT

The village Seed and Bulb,
Fills all our planting needs,
From outdoor bins of onion sets,
To summer's flowering seeds.

The Bluebird's busy all year long.
I think you know the reason.
It's springtime in a gardener's heart,
No matter what the season.

PERSONAL *Notes*

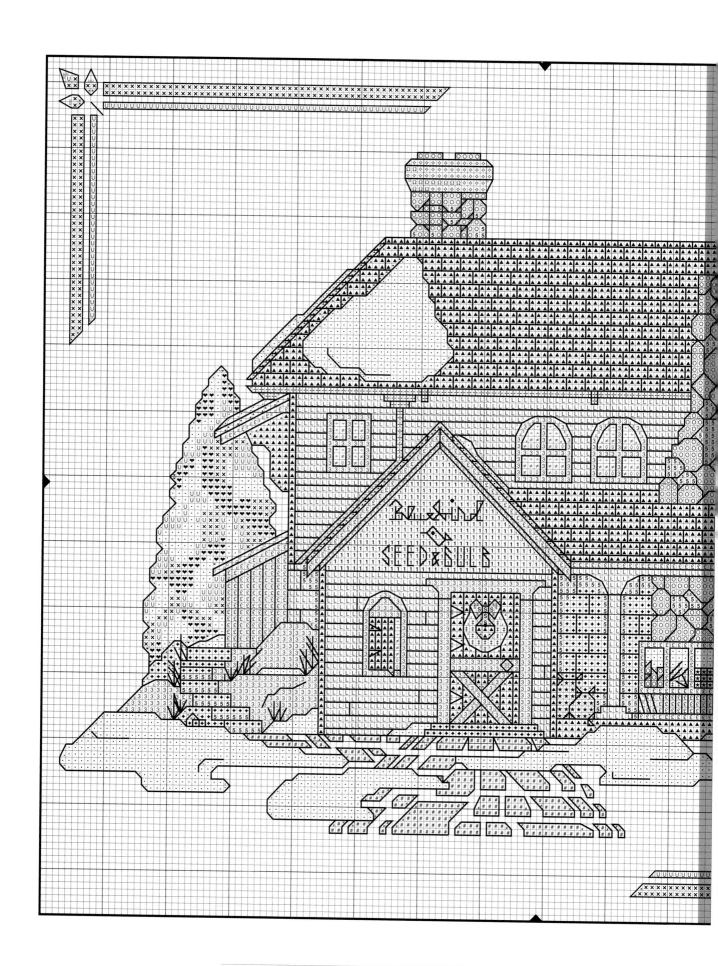

BLUEBIRD SEED AND BULB
p a t t e r n

COLOR KEY

SYMBOL	COLOR	DMC	ANCHOR
•	White	000	2
s	Med. Christmas Red	304	1006
◆	Lt. Steel Gray	318	399
#	Dk. Mahogany	400	351
5	Dk. Shell Gray	451	233
♥	Vy. Dk. Blue Green	500	683
×	Dk. Blue Green	501	878
U	Blue Green	502	877
1	Ultra Vy. Lt. Beige Brown	543	933
★	Med. Old Gold	729	890
◊	Med. Tangerine	741	304
≠	Med. Yellow	743	302
÷	Lt. Pale Yellow	745	300
▲	Dk. Beige Brown	839	360
L	Dk. Pink Beige	842	388
‡	Dk. Emerald Green	910	229
o	Vy. Lt. Rose Brown	950	4146
3	Hunter Green	3346	267
£	Terra Cotta	3830	5975

special instructions

Refer to pages 94-95 for general stitching information. Use 2 strands of floss for cross stitches and 1 strand for backstitches, unless otherwise noted.

BLENDED STITCHES

÷ {	Pearl Gray (2 str)	415	398
	Silver blending filament (1 str)	001BF	001BF

BACKSTITCHES

—	Black (2 str) - Shop name	310	403
—	Lt. Steel Gray - All snow and ice	318	399
—	Vy. Dk. Blue Green - All trees and borders	500	683
—	Black Brown - All else	3371	382

FRENCH KNOTS

•	Black (2 str) - "i" dot in Bluebird and eye of bird	310	403
•	Black Brown (2 str) - Nail on pulley	3371	382

Fabric: 14-count natural Aida
Stitch Count: 154 wide × 127 high

PIGEONHEAD LIGHTHOUSE

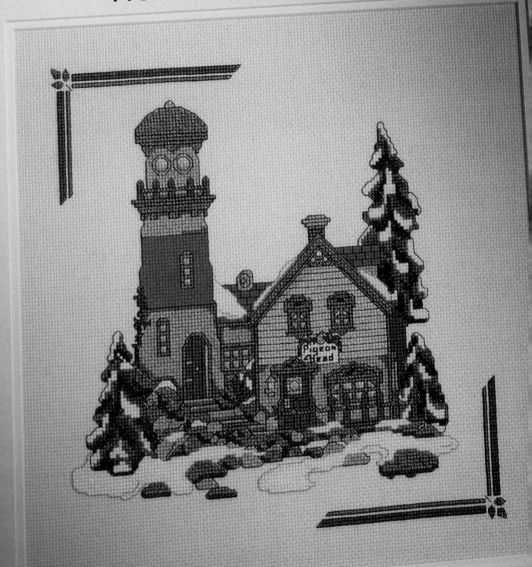

FINISHED DESIGN SIZE: 9 5/8" X 9 1/2"
FRAME SIZE: 19 3/4" X 20 1/4"

PIGEONHEAD LIGHTHOUSE

ISSUED in 1994 CURRENT

Pigeonhead stands red and bold
Against the icy sea.
Nestled in a bed of rock,
To keep the sailors free.

Each night the keeper climbs the stair,
And lights the splendid lamp.
He shines the mirror, buffs the brass,
And gives his pipe a tamp.

Down the stair, the night birds call,
And warn him of a coming squall.
He smiles into the drizzling haze,
Knowing that his light's ablaze.

PERSONAL *Notes*

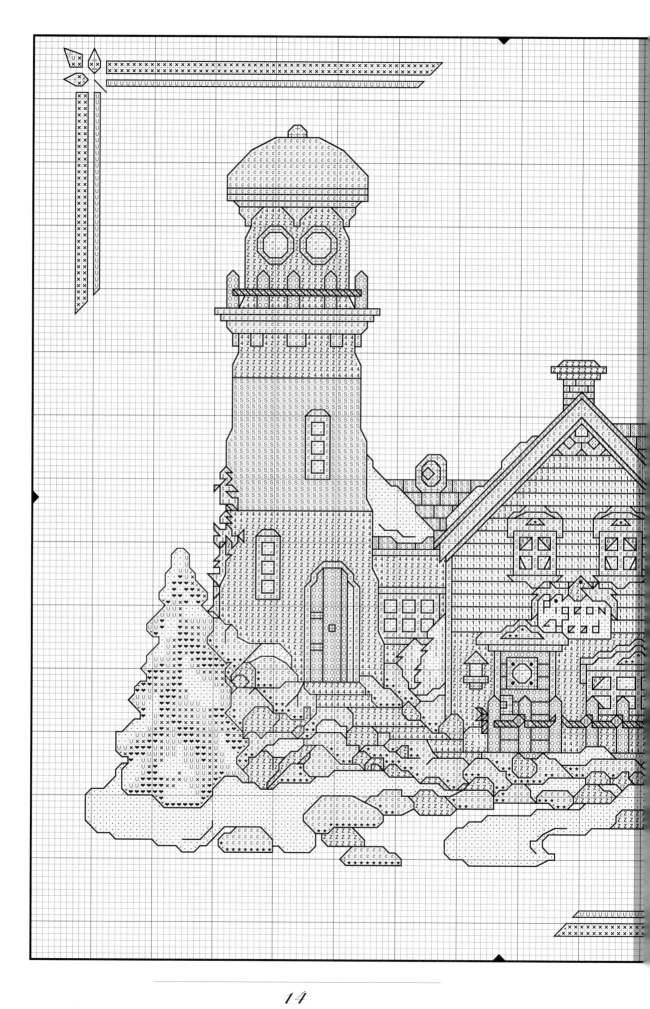

PIGEONHEAD LIGHTHOUSE
p a t t e r n

COLOR KEY

SYMBOL	COLOR	DMC	ANCHOR
•	White	000	2
s	Deep Rose	309	42
★	Dk. Pewter Gray	413	401
4	Dk. Steel Gray	414	235
3	Pearl Gray	415	398
❤	Vy. Dk. Blue Green	500	683
✕	Dk. Blue Green	501	878
u	Blue Green	502	877
◊	Med. Tangerine	741	304
≠	Med. Yellow	743	302
÷	Lt. Pale Yellow	745	300
1	Vy. Lt. Pearl Gray	762	234
▲	Dk. Beige Brown	839	360
‡	Dk. Emerald Green	910	229
6	Med. Golden Brown	976	1001
o	Dk. Khaki Green	3011	846

special instructions

Refer to pages 94-95 for general stitching information. Use 2 strands of floss for cross stitches and 1 strand for backstitches, unless otherwise noted.

BLENDED STITCHES

÷ {	Pearl Gray (2 str)	415	398
	Silver blending filament (1 str)	001BF	001BF
z {	Lt. Steel Gray (1 str)	318	399
	Vy. Lt. Beaver Gray (1 str)	3072	847
¢ {	Lt. Gray Green (1 str)	927	848
	Pewter Gray (1 str)	317	400

BACKSTITCHES

—	Black (2 str) - Lighthouse name	310	403
—	Lt. Steel Gray - All snow and ice	318	399
—	Vy. Dk. Blue Green - All trees and borders	500	683
—	Black Brown - All else	3371	382

FRENCH KNOTS

●	Black (2 str) - "i" dot in Pigeonhead	310	403
●	Black Brown - eye of pigeon and nails on front door window	3371	382

Fabric: 14-count natural Aida
Stitch Count: 143 wide × 142 high

SLEEPY HOLLOW SCHOOL

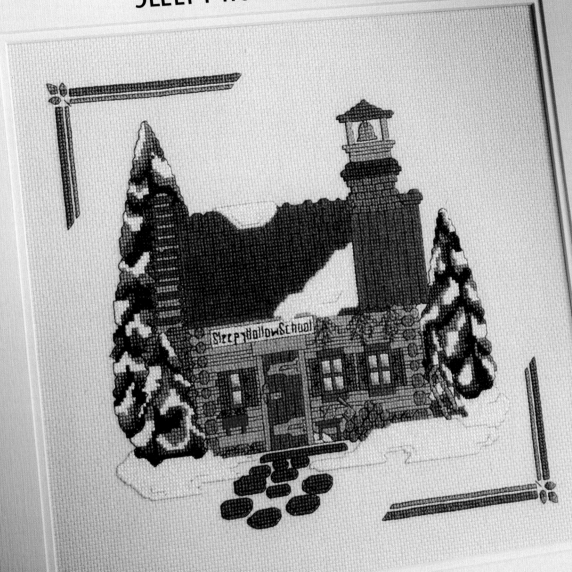

FINISHED DESIGN SIZE: 10 3/8" X 9"
FRAME SIZE: 20" X 19"

JACOB ADAMS BARN

ISSUED in 1986 RETIRED in 1989

The farmyard's full of sights and sounds.
Inside the barn, the noise compounds.
Chickens squawk and roosters crow.
At dusk, we hear the cattle low.

While goats and geese and sheep cavort,
A pen of pigs will loudly snort.
But nightfall stills this busy hum,
And quiets pandemonium.

PERSONAL *Notes*

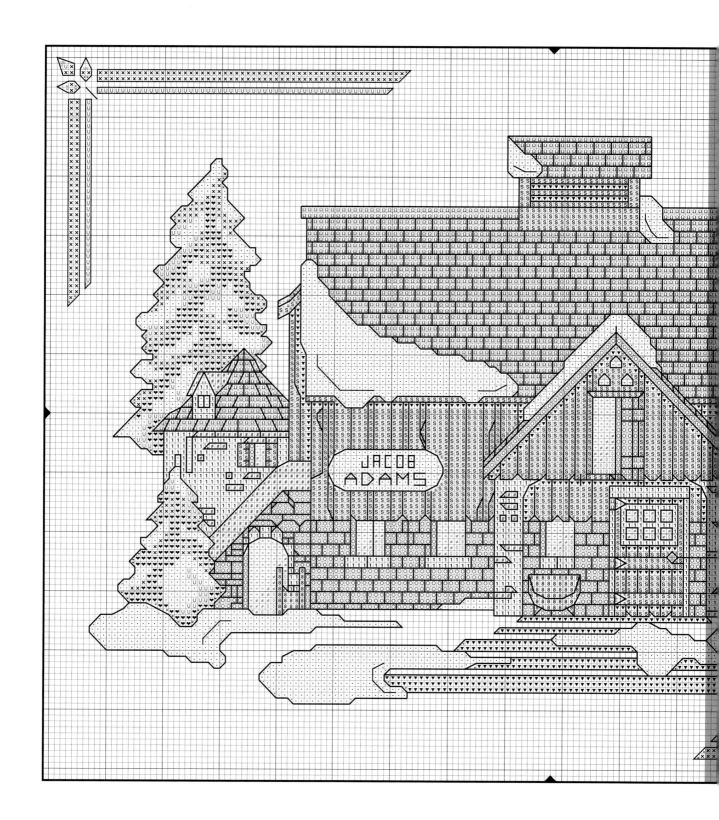

JACOB ADAMS BARN
p a t t e r n

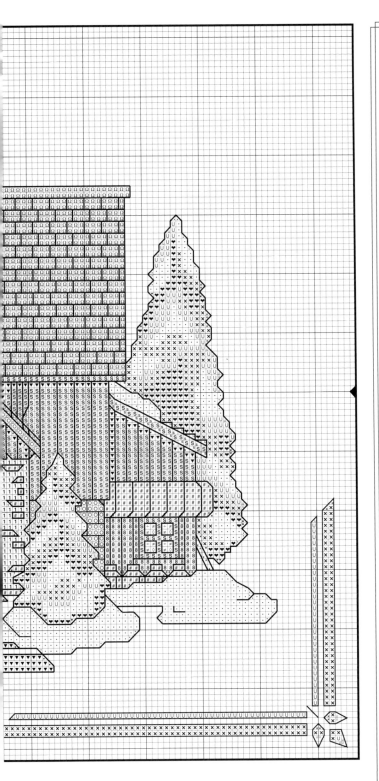

COLOR KEY

SYMBOL	COLOR	DMC	ANCHOR
•	White	000	2
s	Med. Christmas Red	304	1006
Ω	Pewter Gray	317	400
♥	Vy. Dk. Blue Green	500	683
×	Dk. Blue Green	501	878
u	Blue Green	502	877
◊	Med. Tangerine	741	304
≠	Med. Yellow	743	302
÷	Lt. Pale Yellow	745	300
1	Vy. Lt. Pearl Gray	762	234
▼	Med. Garnet	815	43
#	Med. Beige Brown	840	379
8	Lt. Yellow Green	3348	264
o	Vy. Dk. Pink Beige	3773	1008

special instructions

Refer to pages 94-95 for general stitching information. Use 2 strands of floss for cross stitches and 1 strand for backstitches, unless otherwise noted.

BACKSTITCHES

—	Black	310	403
	- Farm name		
—	Lt. Steel Gray	318	399
	- All snow and ice		
—	Vy. Dk. Blue Green	500	683
	- All trees and borders		
—	Black Brown	3371	382
	- All else		

Fabric: 14-count natural Aida
Stitch Count: 174 wide × 120 high

ANNE SHAW TOYS

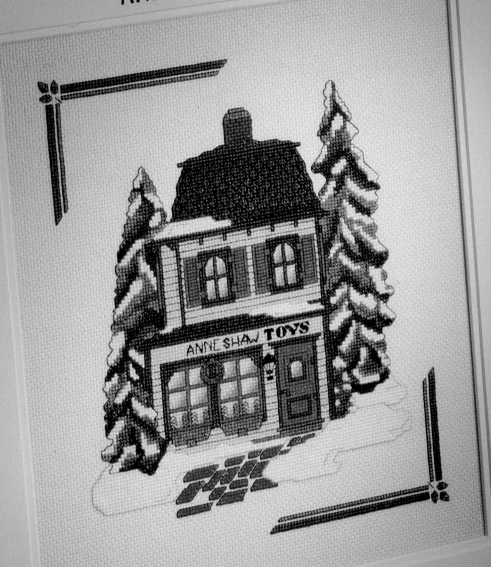

FINISHED DESIGN SIZE: 8 3/8" X 9 7/8"
FRAME SIZE: 18" X 20"

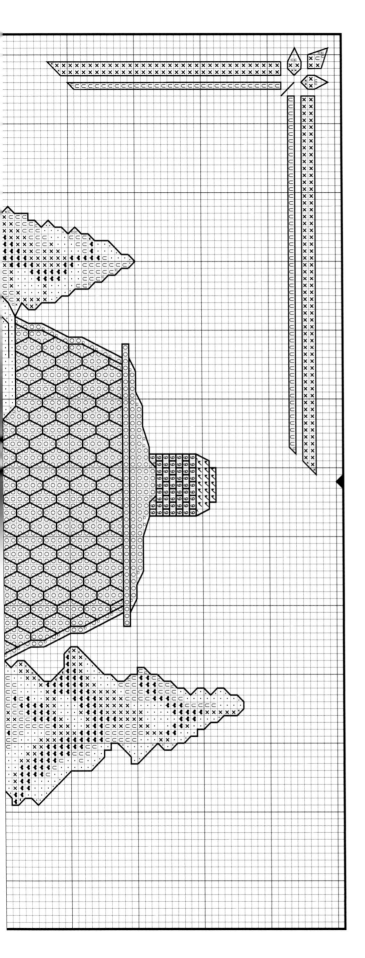

ANNE SHAW TOYS
p a t t e r n

COLOR KEY

SYMBOL	COLOR	DMC	ANCHOR	SYMBOL	COLOR	DMC	ANCHOR
·	White	000	2	π	Med. Beige Gray	644	830
s	Med. Christmas Red	304	1006	1	Ultra Vy. Lt. Tan	739	387
■	Black	310	403	◇	Med. Tangerine	741	304
✓	Dk. Steel Gray	414	235	≠	Med. Yellow	743	302
♥	Vy. Dk. Blue Green	500	683	÷	Lt. Pale Yellow	745	300
✗	Dk. Blue Green	501	878	‡	Dk. Emerald Green	910	229
u	Blue Green	502	877	9	Red Copper	919	340
o	Dk. Fern Green	520	862	3	Terra Cotta	3830	5975

BACKSTITCHES

SYMBOL	COLOR	DMC	ANCHOR
—	Black (2 str)	310	403
-	Shop name		
—	Lt. Steel Gray	318	399
-	All snow and ice		
—	Vy. Dk. Blue Green	500	683
-	All trees and borders		
—	Dk. Emerald Green (2 str)	910	229
-	Plants in window box		
—	Black Brown	3371	382
-	All else		

special instructions

Refer to pages 94-95 for general stitching information. Use 2 strands of floss for cross stitches and 1 strand for backstitches, unless otherwise noted.

Fabric: 14-count natural Aida
Stitch Count: 126 wide × 148 high

BLUE STAR ICE CO.

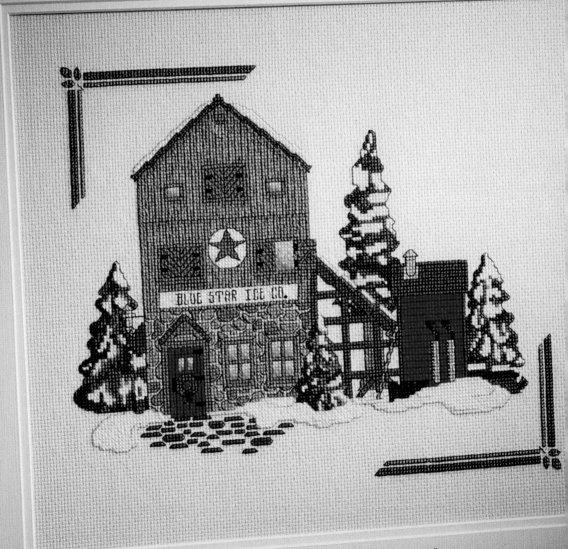

FINISHED DESIGN SIZE: 10 5/8" X 8 7/8"
FRAME SIZE: 20 1/2" X 19 1/4"

BLUE STAR ICE CO.

ISSUED in 1993 CURRENT

The lake is scored and cut,
Into a checkerboard of blocks.
At harvest time the saws sing out,
For yields that sag the docks.

The crop will travel up the ramp,
Where sawdust waits within.
Where blocks of ice will sleep for months,
Away from all the din.

When summer comes with parching winds,
The wagons reappear.
This time to bring the blocks of ice,
To houses far and near.

PERSONAL *Notes*

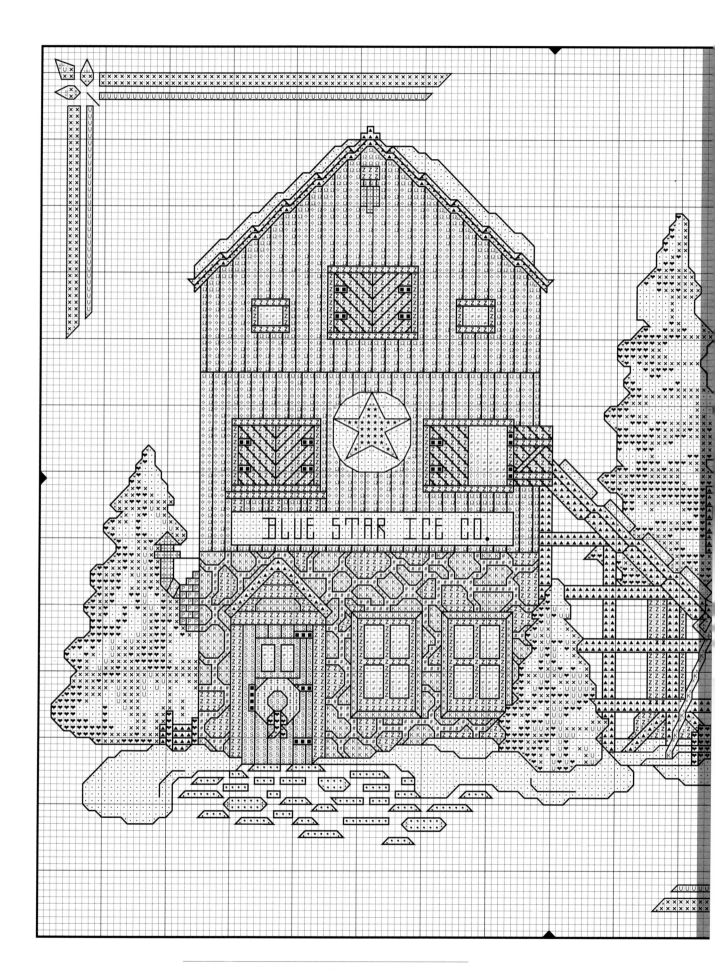

BLUE STAR ICE CO.
p a t t e r n

COLOR KEY

SYMBOL	COLOR	DMC	ANCHOR
•	White	000	2
s	Med. Christmas Red	304	1006
■	Black	310	403
✧	Lt. Steel Gray	318	399
P	Dk. Terra Cotta	355	1014
Ω	Dk. Steel Gray	414	235
♥	Vy. Dk. Blue Green	500	683
×	Dk. Blue Green	501	878
U	Blue Green	502	877
◊	Med. Tangerine	741	304
≠	Med. Yellow	743	302
÷	Lt. Pale Yellow	745	300
•	Dk. Coffee Brown	801	359
▲	Dk. Beige Brown	839	360
z	Med. Beige Brown	840	379
κ	Lt. Beige Brown	841	378
#	Vy. Lt. Beige Brown	842	388
‡	Dk. Emerald Green	910	229
★	Wedgewood	3760	169

special instructions

Refer to pages 94-95 for general stitching information. Use 2 strands of floss for cross stitches and 1 strand for backstitches, unless otherwise noted.

BLENDED STITCHES

÷ {	Pearl Gray (2 str)	415	398
	Silver blending filament (1 str)	001BF	001BF

BACKSTITCHES

— Black (2 str) 310 403
 - Company name
— Black - Hinges, handles on 310 403
 door and saws and all silver
 blended metallic stitches
— Lt. Steel Gray 318 399
 - All snow and ice
— Vy. Dk. Blue Green 500 683
 - All trees and borders
— Black Brown - All else 3371 382

FRENCH KNOTS

● Black (2 str) 310 403
 - Sign punctuation

Fabric: 14-count natural Aida
Stitch Count: 156 wide × 130 high

NATHANIEL BINGHAM FABRICS

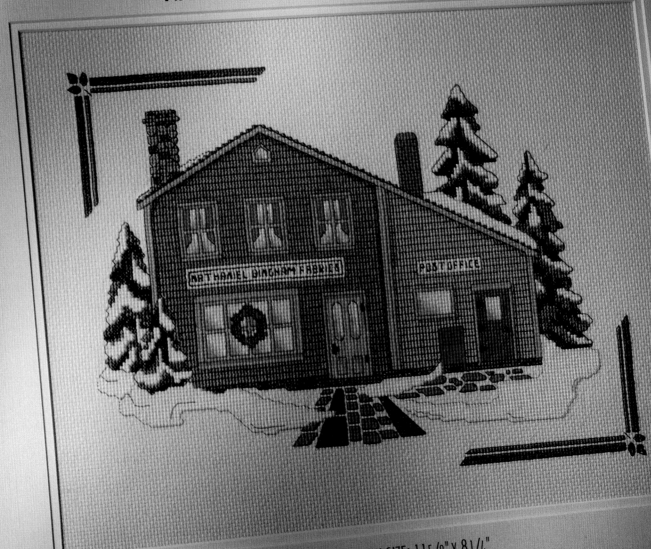

FINISHED DESIGN SIZE: 11 5/8" X 8 1/4"
FRAME SIZE: 21" X 18 1/4"

NATHANIEL BINGHAM FABRICS

ISSUED in 1986

RETIRED in 1989

Broadloom, crinoline, calico, chintz.
Fabric by the bolt or the yard or the inch.
Drawers full of buttons, pails full of hooks.
Bingham sells them all to ensure good looks.

PERSONAL *Notes*

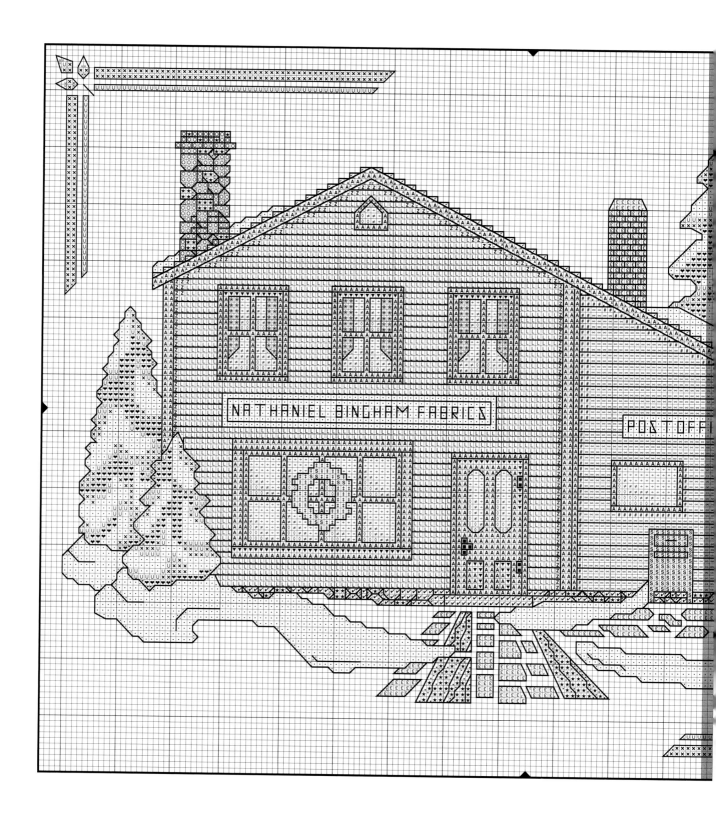

NATHANIEL BINGHAM FABRICS

POST OFF

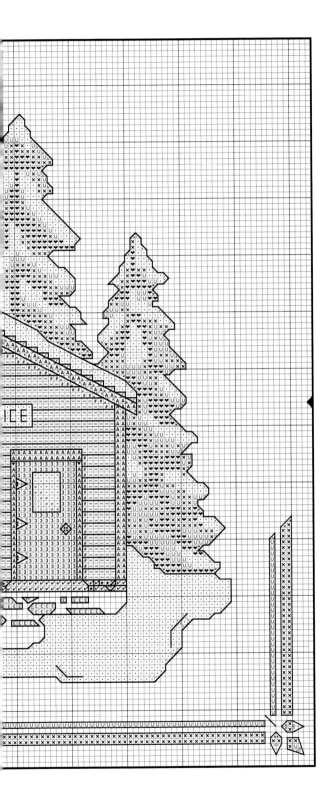

COLOR KEY

SYMBOL	COLOR	DMC	ANCHOR
•	White	000	2
✿	Deep Rose	309	42
■	Black	310	403
s	Vy. Deep Rose	326	59
o	Med. Rose Brown	407	914
✔	Dk. Steel Gray	414	235
❤	Vy. Dk. Blue Green	500	683
✕	Dk. Blue Green	501	878
U	Blue Green	502	877
#	Fern Green	522	860
3	Vy. Dk. Rose Brown	632	936
A	Lt. Orange Spice	722	323
◊	Med. Tangerine	741	304
≠	Med. Yellow	743	302
÷	Lt. Pale Yellow	745	300
★	Dk. Coffee Brown	801	359
‡	Dk. Emerald Green	910	229
z	Hunter Green	3346	267
L	Med. Hunter Green	3347	266
∞	Lt. Yellow Green	3348	264
▼	Lt. Mahogany	3776	1048
£	Terra Cotta	3830	5975

special instructions

Refer to pages 94-95 for general stitching information. Use 2 strands of floss for cross stitches and 1 strand for backstitches, unless otherwise noted.

BACKSTITCHES

—	Black (2 str)	310	403
	- Shop names		
—	Lt. Steel Gray	318	399
	- All snow and ice		
—	Vy. Dk. Blue Green	500	683
	- All trees and borders		
—	Black Brown	3371	382
	- All else		

Fabric: 14-count natural Aida
Stitch Count: 174 wide × 124 high

ARLINGTON FALLS CHURCH

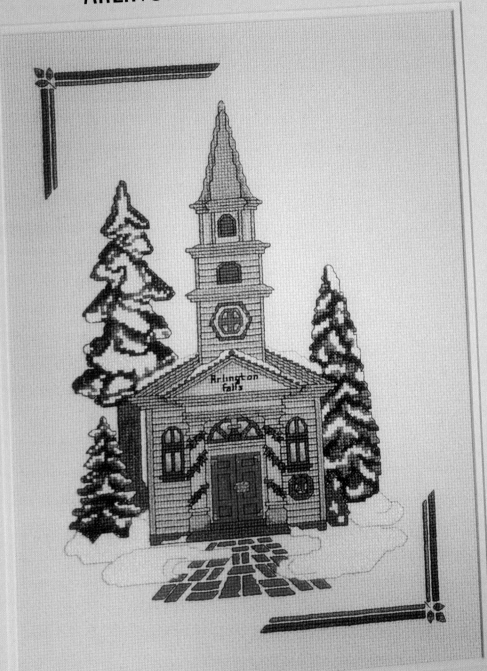

FINISHED DESIGN SIZE: 8 7/8" X 12 3/4"
FRAME SIZE: 18 1/2" X 23"

ARLINGTON FALLS CHURCH

ISSUED in 1994 CURRENT

The towering steeple calls the people,
From all across the glen.
The clapboard siding and whitewashed walls,
Beckon to all men.

On clear spring days, the organ plays,
A chorus rises high,
And fills the air with joyful noise,
As congregants comply.

PERSONAL *Notes*

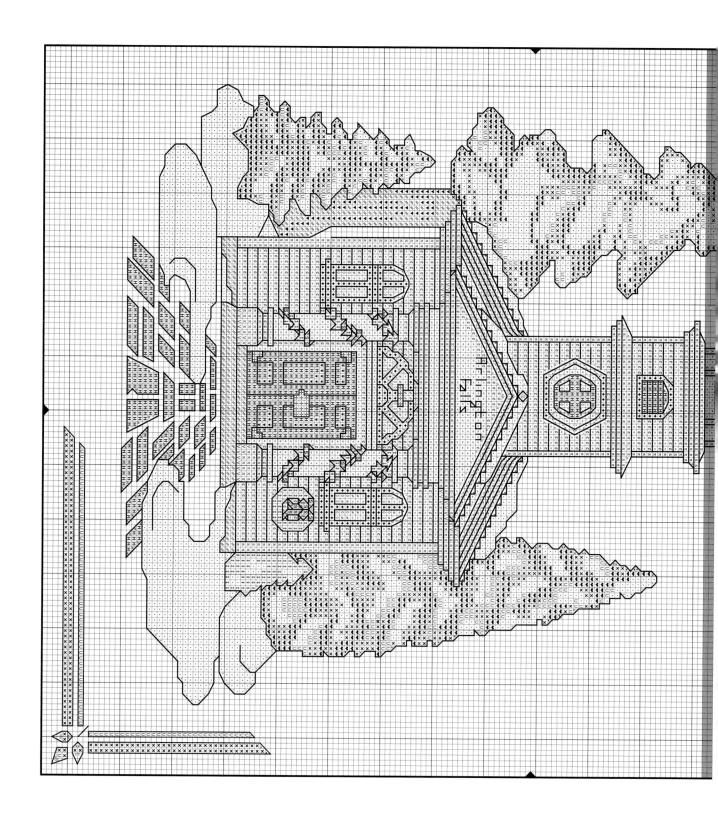

COLOR KEY

SYMBOL	COLOR	DMC	ANCHOR	SYMBOL	COLOR	DMC	ANCHOR
•	White	000	2	≠	Med. Yellow	743	302
s	Med. Christmas Red	304	1006	÷	Lt. Pale Yellow	745	300
	Dk. Terra Cotta	355	1014	"	Vy. Lt. Pearl Gray	762	234
¢	Pearl Gray	415	398	▼	Dk. Beige Brown	839	360
	Vy. Dk. Blue Green	500	683	‡	Dk. Emerald Green	910	229
u	Dk. Blue Green	501	878	◆	Hunter Green	3346	267
×	Blue Green	502	877	◊	Ultra Dk. Beige Gray	3790	393
◊	Med. Tangerine	741	304	H	Terra Cotta	3830	5975

BLENDED STITCHES

SYMBOL	COLOR	DMC	ANCHOR
+ {	Med. Old Gold (2 str)	729	890
	Gold blending filament (1 str) 002BF	002BF	
v {	Pewter Gray (1 str)	317	400
	Lt. Gray Green (1 str)	927	848
π {	Lt. Steel Gray (1 str)	318	399
	Vy. Lt. Beaver Gray (1 str)	3072	847

BACKSTITCHES

SYMBOL	COLOR	DMC	ANCHOR
—	Black (2 str) - Church name	310	403
—	Lt. Steel Gray - All snow and ice	318	399
—	Vy. Dk. Blue Green - All trees and borders	500	683
—	Black Brown - All else	3371	382

special instructions

Refer to pages 94-95 for general stitching information. Use 2 strands of floss for cross stitches and 1 strand for backstitches, unless otherwise noted.

Fabric: 14-count natural Aida
Stitch Count: 130 wide × 184 high

BEN'S BARBERSHOP

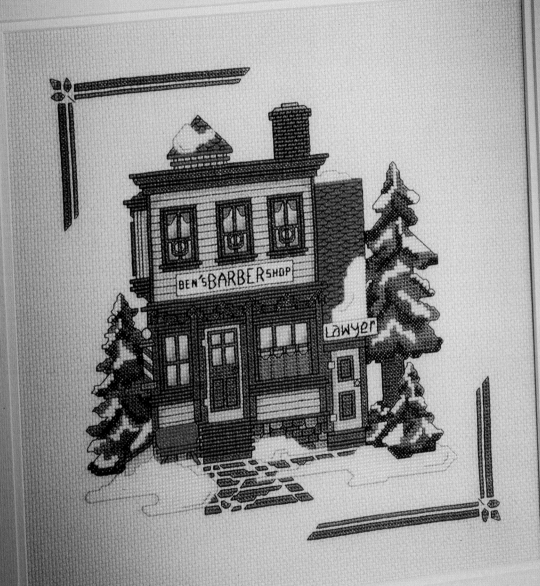

FINISHED DESIGN SIZE: 9" X 91/4"
FRAME SIZE: 183/4" X 193/8"

BEN'S BARBER SHOP

Lawyer

BEN'S BARBERSHOP

ISSUED in 1988 RETIRED in 1990

Ben always has a friendly smile,
And waits beside his chair.
For years he's stood and greeted,
All the men who climb the stair.

The rhythm of his razor,
The meter of his shear,
Confirm to all who enter,
He's a barber without peer.

PERSONAL *Notes*

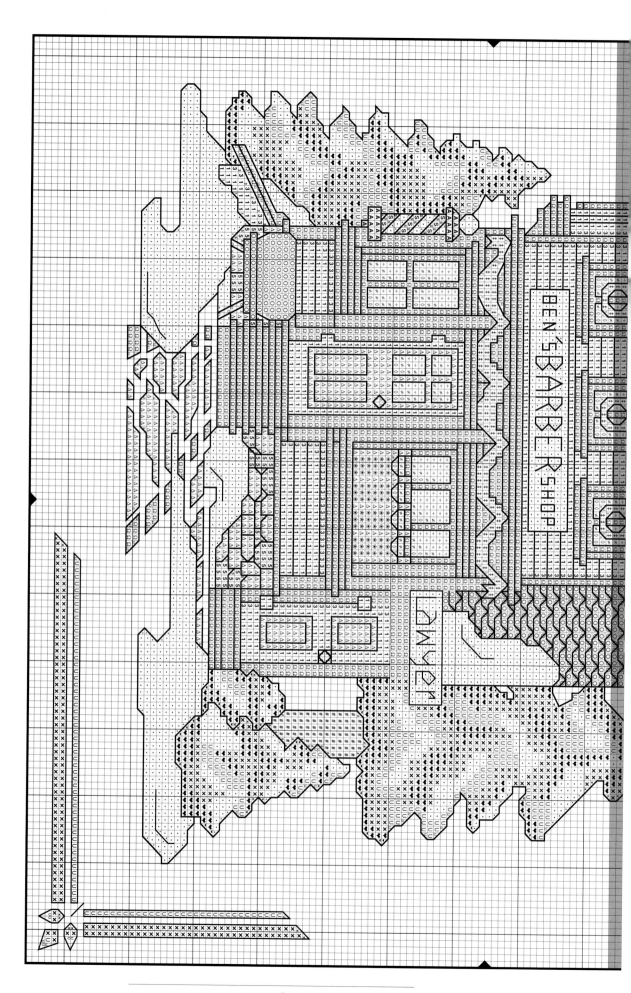

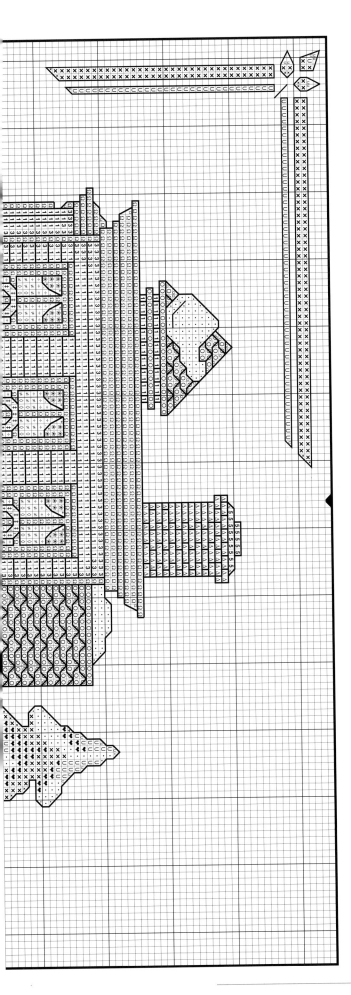

BEN'S BARBERSHOP
pattern

special instructions

Refer to pages 94–95 for general stitching information. Use 2 strands of floss for cross stitches and 1 strand for backstitches, unless otherwise noted.

COLOR KEY

SYMBOL	COLOR	DMC	ANCHOR
•	White	000	2
s	Med. Christmas Red	304	1006
5	Lt. Steel Gray	318	399
o	Vy. Dk. Salmon	347	1025
♣	Vy. Dk. Blue Green	500	683
×	Dk. Blue Green	501	878
u	Blue Green	502	877
▵	Dk. Drab Brown	611	898
▲	Med. Drab Brown	612	832

SYMBOL	COLOR	DMC	ANCHOR
Ω	Vy. Dk. Rose Brown	632	936
3	Vy. Lt. Tan	738	361
1	Ultra Vy. Lt. Tan	739	387
◊	Med. Tangerine	741	304
≠	Med. Yellow	743	302
÷	Lt. Pale Yellow	745	300
#	Dk. Beige Brown	839	360
‡	Dk. Emerald Green	910	229
❀	Med. Electric Blue	996	433

BACKSTITCHES

SYMBOL	COLOR	DMC	ANCHOR
—	Black (2 str)	310	403
-	Shop names		
—	Lt. Steel Gray	318	399
-	All snow and ice		
—	Vy. Dk. Blue Green	500	683
-	All trees and borders		
—	Black Brown	3371	382
-	All else		

Fabric: 14-count natural Aida
Stitch Count: 134 wide × 138 high

McGrebe-Cutters & Sleighs

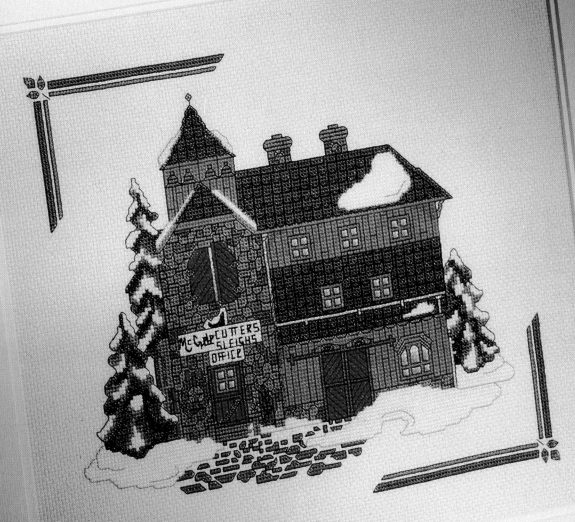

FINISHED DESIGN SIZE: 10 3/8" x 8 5/8"
FRAME SIZE: 20" x 18 3/4"

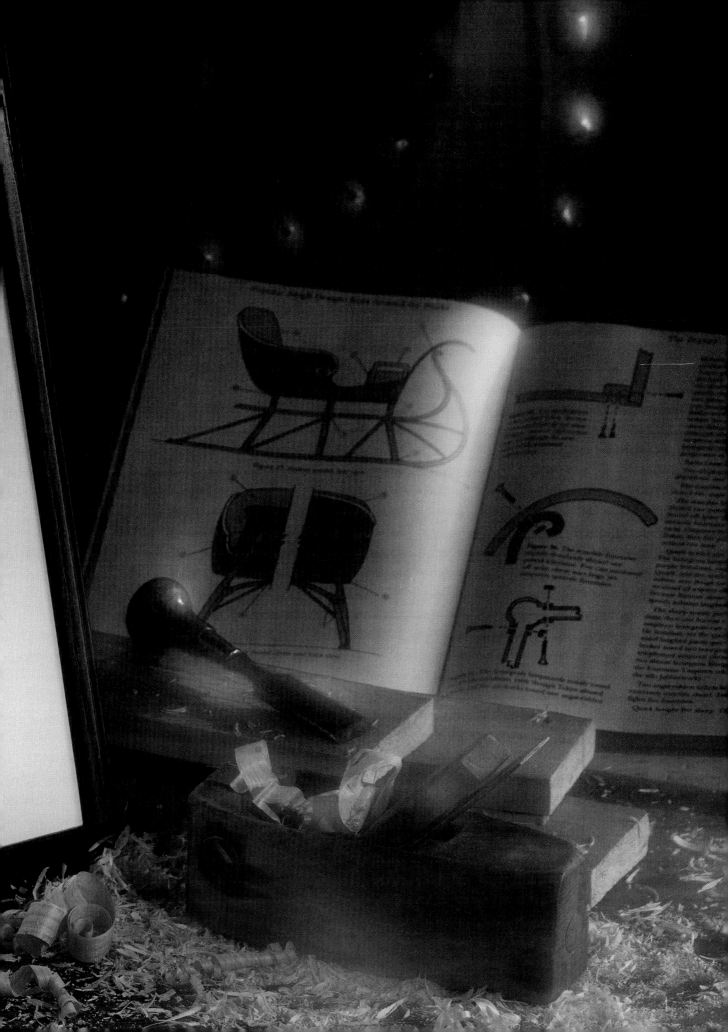

McGREBE-CUTTERS & SLEIGHS

ISSUED in 1991 RETIRED in 1995

To hasten through the winter snow,
You need a sleigh or cutter.
McGrebe's the man who builds the best.
They cut the snow like butter.

Curing birch and bowing cedar,
Pounding out sleek blades.
Construction is the builder's art,
On which he shall be paid.

PERSONAL *Notes*

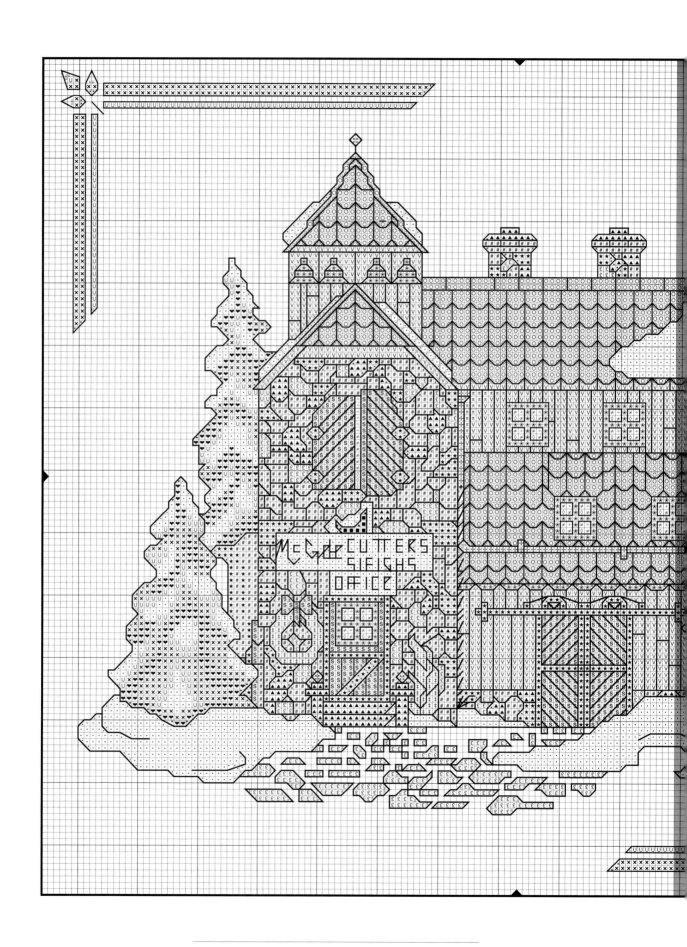

McGREBE—CUTTERS & SLEIGHS
p a t t e r n

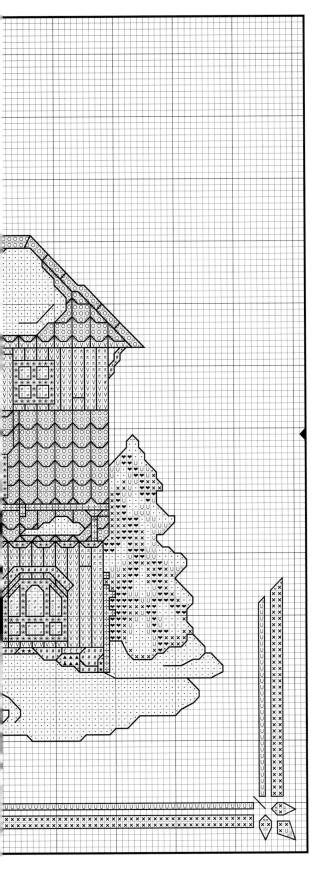

COLOR KEY

SYMBOL	COLOR	DMC	ANCHOR
•	White	000	2
■	Black	310	403
▲	Dk. Steel Gray	414	235
s	Dk. Christmas Red	498	1005
❤	Vy. Dk. Blue Green	500	683
×	Dk. Blue Green	501	878
u	Blue Green	502	877
◊	Med. Tangerine	741	304
≠	Med. Yellow	743	302
÷	Lt. Pale Yellow	745	300
★	Dk. Beige Brown	839	360
#	Med. Beige Brown	840	379
‡	Dk. Emerald Green	910	229
v	Med. Golden Brown	976	1001
£	Dk. Khaki Green	3011	846
o	Dk. Pine Green	3362	263
❀	Dk. Turquoise	3810	168
π	Golden Brown	3826	1049

special instructions

Refer to pages 94-95 for general stitching
information. Use 2 strands of floss for cross
stitches and 1 strand for backstitches,
unless otherwise noted.

BLENDED STITCHES

÷ {	Pearl Gray (2 str)	415	398
	Silver blending filament (1 str)	001BF	001BF

BACKSTITCHES

—	Black (2 str)	310	403
	- Shop name and "office"		
—	Lt. Steel Gray	318	399
	- All snow and ice		
—	Vy. Dk. Blue Green	500	683
	- All trees and borders		
—	Dk. Emerald Green (2 str)	910	229
	- Garland on gutter		
—	Black Brown	3371	382
	- All else		

Fabric: 14-count natural Aida
Stitch Count: 153 wide × 130 high

ADA'S BED AND BOARDING HOUSE

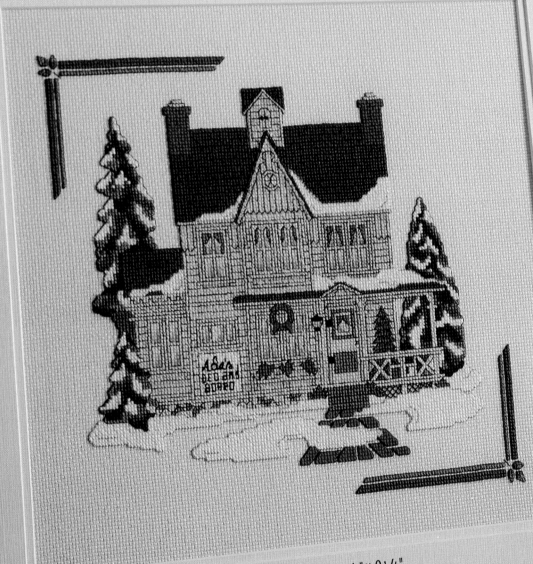

FINISHED DESIGN SIZE: 10 1/2" X 9 1/4"
FRAME SIZE: 19 7/8" X 19"

ADA'S BED AND BOARDING HOUSE

ISSUED in 1988 RETIRED in 1991

Her parlor is a place,
Where conversations percolate.
As travelers come and go,
Her warmth and grace predominate.

Featherbeds and linen,
Await the weary heads.
All sleep well at this hotel,
On Ada's downy beds.

PERSONAL *Notes*

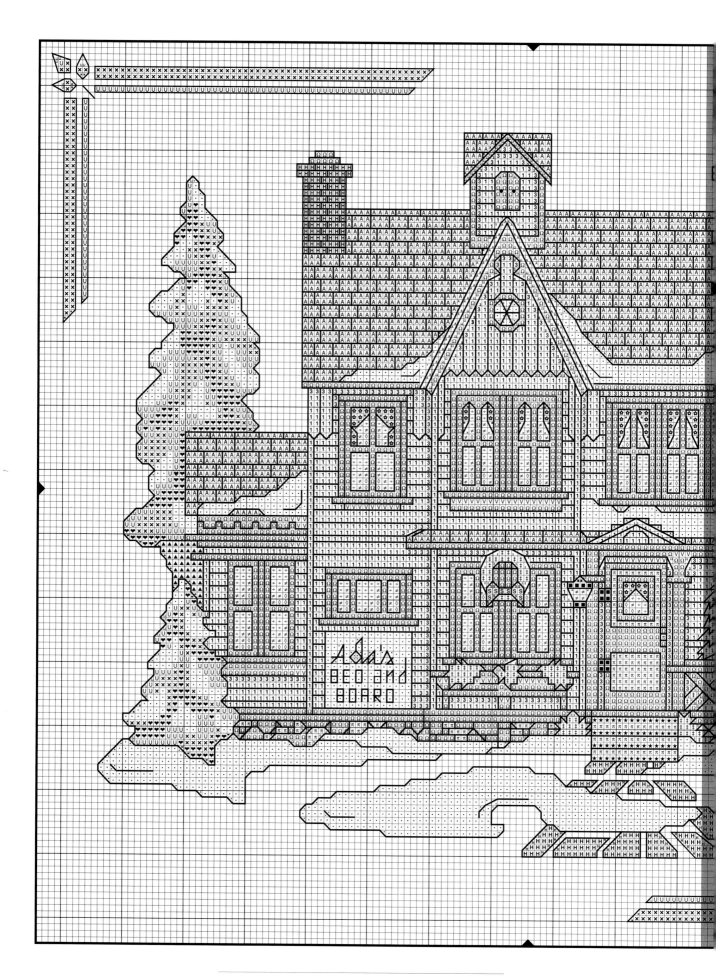

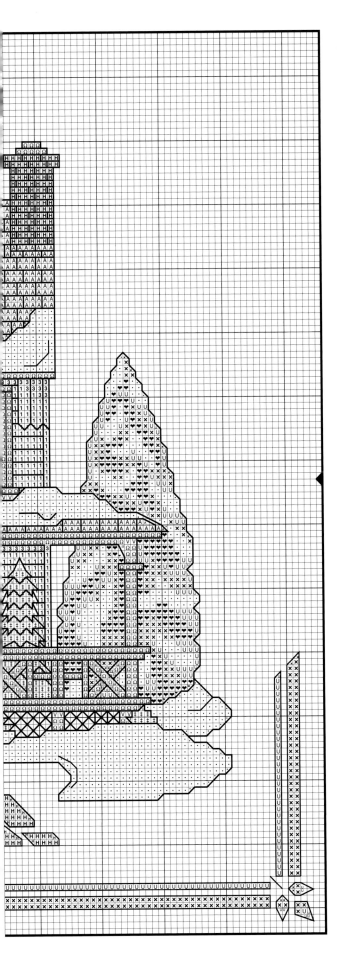

COLOR KEY

SYMBOL	COLOR	DMC	ANCHOR
•	White	000	2
s	Med. Christmas Red	304	1006
■	Black	310	403
★	Pewter Gray	317	400
π	Dk. Steel Gray	414	235
v	Pearl Gray	415	398
❤	Vy. Dk. Blue Green	500	683
×	Dk. Blue Green	501	878
U	Blue Green	502	877
3	Lt. Old Gold	676	891
1	Vy. Lt. Old Gold	677	886
◊	Med. Tangerine	741	304
≠	Med. Yellow	743	302
÷	Lt. Pale Yellow	745	300
Ω	Vy. Lt. Pearl Gray	762	234
✿	Dk. Peacock Blue	806	169
▲	Dk. Beige Brown	839	360
‡	Dk. Emerald Green	910	229
A	Dk. Antique Blue	930	1035
H	Dk. Golden Brown	975	355

special instructions

Refer to pages 94-95 for general stitching information. Use 2 strands of floss for cross stitches and 1 strand for backstitches, unless otherwise noted.

BACKSTITCHES

—	Black (2 str) - House name	310	403
—	Lt. Steel Gray - All snow and ice	318	399
—	Vy. Dk. Blue Green - All trees and borders	500	683
—	Black Brown - All else	3371	382

FRENCH KNOTS

●	Black Brown (2 str) - Knobs on cupola shutters	3371	382

Fabric: 14-count natural Aida
Stitch Count: 156 wide × 137 high

JANNES MULLET AMISH BARN

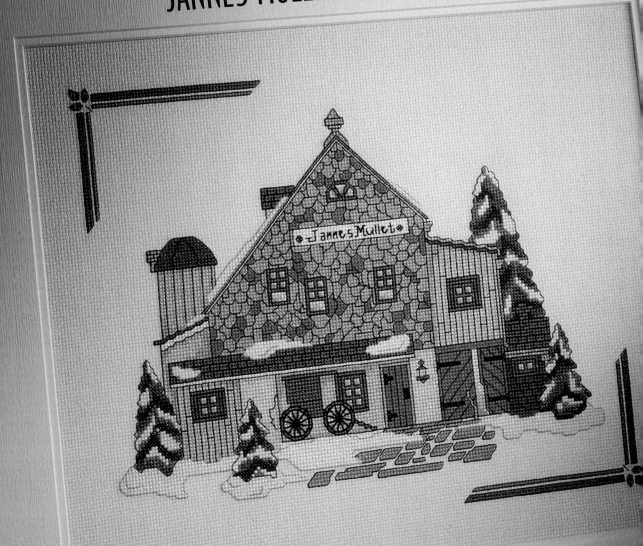

FINISHED DESIGN SIZE: 12 1/8" x 9 1/8"
FRAME SIZE: 21 3/4" x 19 1/4"

JANNES MULLET AMISH BARN

ISSUED in 1989 RETIRED in 1992

A field of glistening corn grows tall,
While Mullet's children pick and haul,
A pail of berries ripe and red,
That grow beside the garden shed.

The family harvests all their larder.
What they don't use, they trade or barter.
The Amish are a happy band.
They live in peace upon the land.

PERSONAL *Notes*

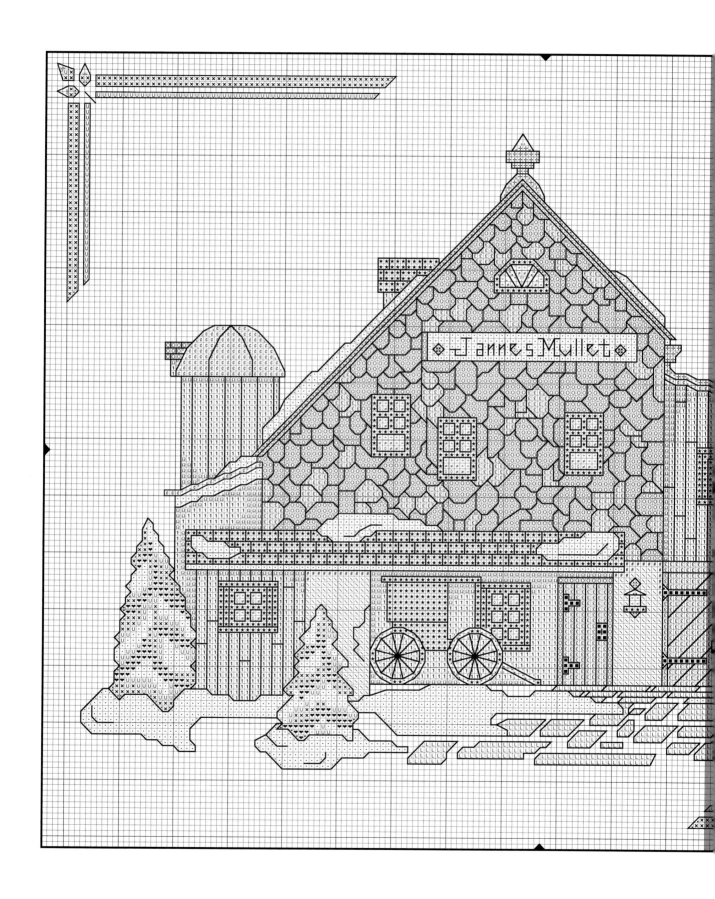

JANNES MULLET AMISH BARN
p a t t e r n

COLOR KEY

SYMBOL	COLOR	DMC	ANCHOR
•	White	000	2
s	Black	310	403
★	Pewter Gray	317	400
Ω	Pearl Gray	415	398
o	Lt. Tan	437	362
♥	Vy. Dk. Blue Green	500	683
×	Dk. Blue Green	501	878
u	Blue Green	502	877
¢	Vy. Dk. Olive Green	730	845
#	Vy. Lt. Tan	738	361
\	Ultra Vy. Lt. Tan	739	387
◊	Med. Tangerine	741	304
≠	Med. Yellow	743	302
÷	Lt. Pale Yellow	745	300
1	Vy. Lt. Pearl Gray	762	234
L	Rose Brown	3064	883
£	Terra Cotta	3830	5975

special instructions

Refer to pages 94-95 for general stitching information. Use 2 strands of floss for cross stitches and 1 strand for backstitches, unless otherwise noted.

BLENDED STITCHES

÷ { Pearl Gray (2 str)	415	398
Silver blending filament (1 str)	001BF	001BF

BACKSTITCHES

— Black (2 str) - Farm name and wagon wheel spokes and outlines — 310 — 403

— Black - Blended silver metallic stitches, door hinges, diamonds on sign — 310 — 403

— Lt. Steel Gray - All snow and ice — 318 — 399

— Vy. Dk. Blue Green - All trees and borders — 500 — 683

— Black Brown - All else — 3371 — 382

Fabric: 14-count natural Aida
Stitch Count: 178 wide × 136 high

CAPTAIN'S COTTAGE

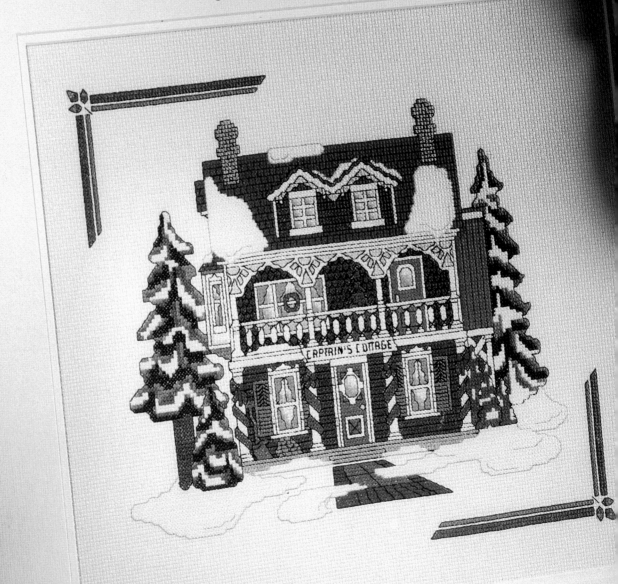

FINISHED DESIGN SIZE: 11" x 9 1/8"
FRAME SIZE: 20 3/4" x 19"

CAPTAIN'S COTTAGE

ISSUED in 1990 CURRENT

The Captain's Cottage snug on shore,
Is a gallery of his travels.
It's filled with silks and porcelains,
Cloisonné and rare enamels.

His years of sailing far and wide,
Are finished on the sea.
Now home is where his heart lies,
And where he wants to be.

PERSONAL *Notes*

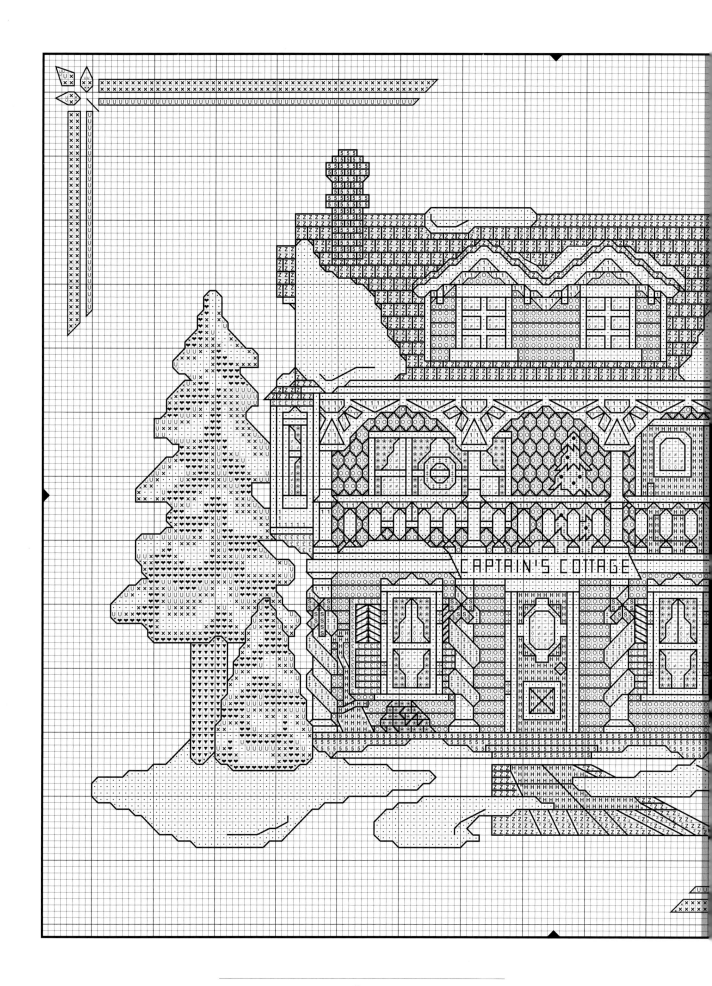

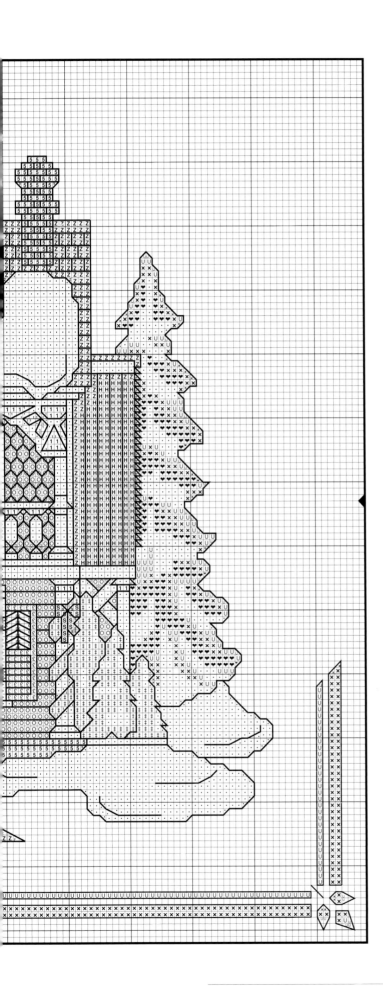

CAPTAIN'S COTTAGE
p a t t e r n

COLOR KEY			
SYMBOL	COLOR	DMC	ANCHOR
•	White	000	2
s	Med. Christmas Red	304	1006
5	Med. Shell Gray	452	232
♥	Vy. Dk. Blue Green	500	683
✕	Dk. Blue Green	501	878
u	Blue Green	502	877
◊	Med. Tangerine	741	304
≠	Med. Yellow	743	302
÷	Lt. Pale Yellow	745	300
1	Vy. Lt. Pearl Gray	762	234
❁	Med. Topaz	783	307
▼	Dk. Beige Brown	839	360
‡	Dk. Emerald Green	910	229
z	Dk. Red Copper	918	341
o	Dk. Aquamarine	991	189
£	Med. Hunter Green	3347	266
H	Terra Cotta	3830	5975

special instructions

Refer to pages 94-95 for general stitching information. Use 2 strands of floss for cross stitches and 1 strand for backstitches, unless otherwise noted.

BLENDED STITCHES

÷ {	Lt. Tan (2 str)	437	362
	Gold blending filament (1 str)	002BF	002BF

BACKSTITCHES

—	Black (2 str) - Cottage name	310	403
—	Lt. Steel Gray - All snow and ice	318	399
—	Vy. Dk. Blue Green - All trees and borders	500	683
—	Black Brown - All else	3371	382

FRENCH KNOTS

•	Med. Christmas Red (2 str) - Bulbs on Christmas tree	304	1006

Fabric: 14-count natural Aida
Stitch Count: 162 wide × 134 high

SMYTHE WOOLEN MILL

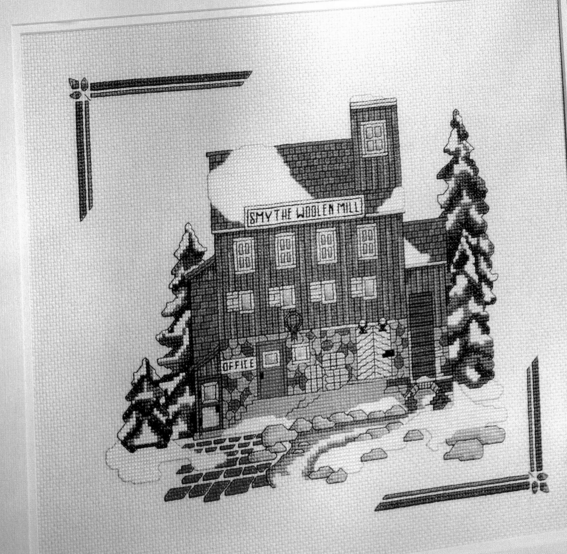

FINISHED DESIGN SIZE: 10 3/4" X 9 1/4"
FRAME SIZE: 20 1/4" X 19 1/4"

SMYTHE WOOLEN MILL

OFFICE

SMYTHE WOOLEN MILL

ISSUED in 1987 RETIRED in 1988

Limited Edition
7,500

Card and spin the finest wool,
From bundled bales stacked high.
Grind and blend in cauldrons full,
The necessary dye.

Select the colors, dip the wool,
And when the threads are dry,
Start the heavy weaving loom,
And let the shuttles fly.

PERSONAL *Notes*

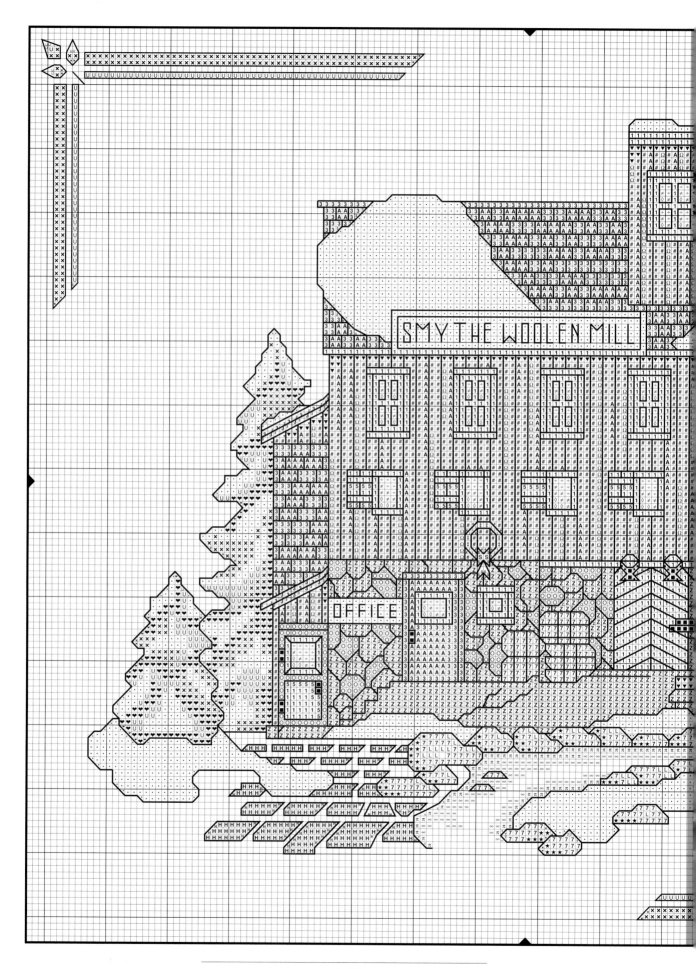

SMYTHE WOOLEN MILL

OFFICE

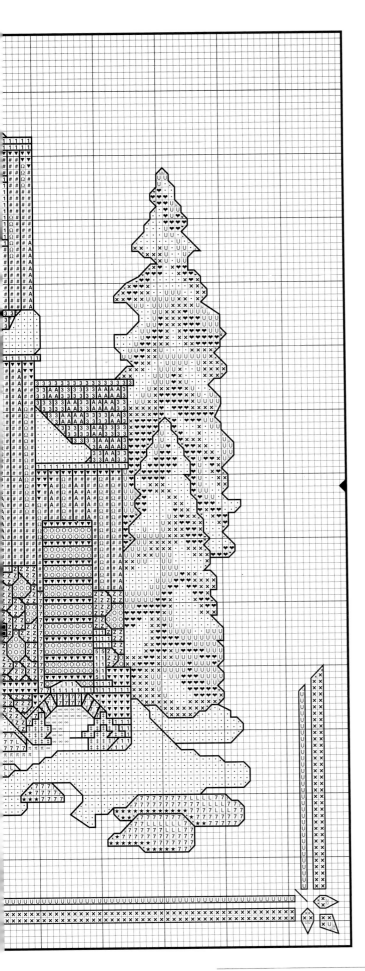

SMYTHE WOOLEN MILL
p a t t e r n

COLOR KEY

SYMBOL	COLOR	DMC	ANCHOR
•	White	000	2
S	Med. Christmas Red	304	1006
■	Black	310	403
★	Lt. Steel Gray	318	399
H	Dk. Terra Cotta	355	1014
A	Med. Terra Cotta	356	5975
7	Pearl Gray	415	398
z	Lt. Tan	437	362
♥	Vy. Dk. Blue Green	500	683
x	Dk. Blue Green	501	878
U	Blue Green	502	877
1	Ultra Vy. Lt. Beige Brown	543	933
o	Vy. Dk. Rose Brown	632	936
◊	Med. Tangerine	741	304
≠	Med. Yellow	743	302
÷	Lt. Pale Yellow	745	300
L	Vy. Lt. Pearl Gray	762	234
▼	Dk. Beige Brown	839	360
#	Med. Beige Brown	840	379
Ω	Lt. Beige Brown	841	378
5	Vy. Lt. Beige Brown	842	388
‡	Dk. Emerald Green	910	229
π	Med. Antique Blue	931	1034
∞	Lt. Antique Blue	932	1033
3	Terra Cotta	3830	5975

special instructions

Refer to pages 94-95 for general stitching information. Use 2 strands of floss for cross stitches and 1 strand for backstitches, unless otherwise noted.

BACKSTITCHES

— Black (2 str) - Mill name and "office"	310	403
— Lt. Steel Gray - All snow and ice	318	399
— Vy. Dk. Blue Green - All trees and borders	500	683
— Black Brown - All else	3371	382

Fabric: 14-count natural Aida
Stitch Count: 159 wide × 139 high

YANKEE JUD BELL CASTING

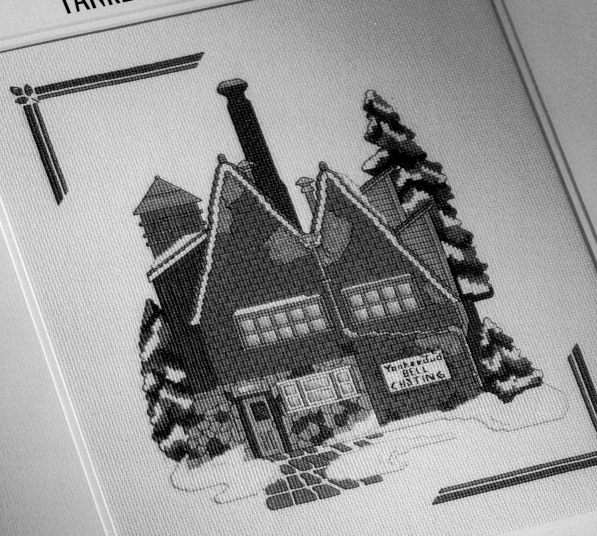

FINISHED DESIGN SIZE: 9 1/4" X 11 1/8"
FRAME SIZE: 19" X 21 1/4"

Yankee Jud
BELL
CASTING

YANKEE JUD BELL CASTING

ISSUED in 1992 RETIRED in 1995

Blasting fires, molten brass,
Molds of every size.
The searing heat and fumes and smoke,
Sometimes fill the skies.

As embers die and chimneys cool,
We know she's cast another.
A bell whose ring is clear and crisp,
And unlike any other.

A bell to peal throughout the hills,
And call to all who hear,
A marriage, meeting, birth or death,
Of someone who lives near.

PERSONAL *Notes*

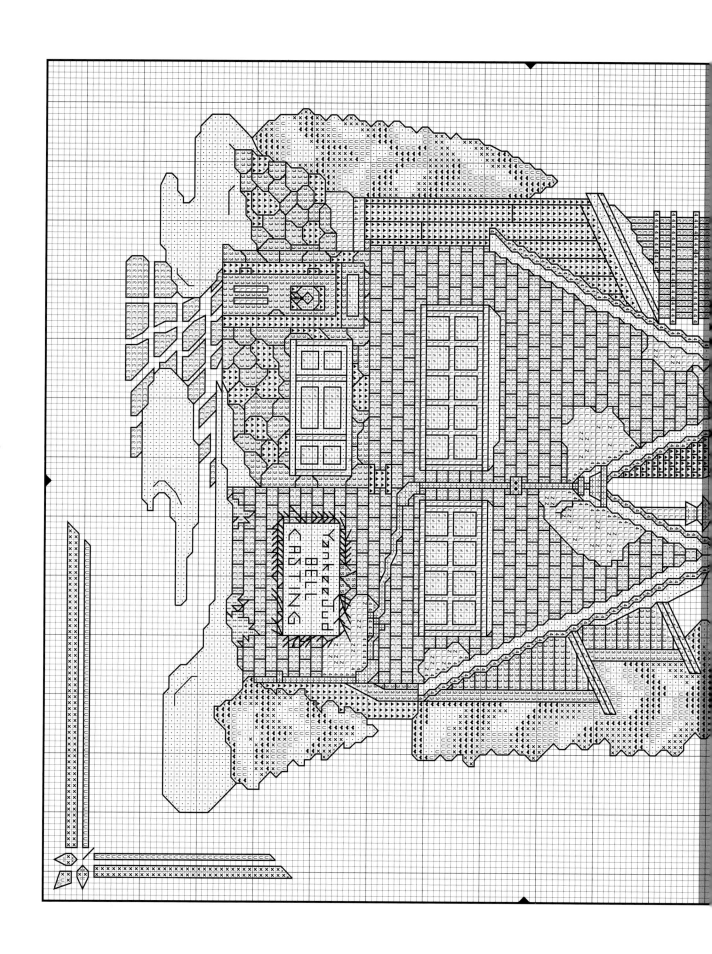

COLOR KEY

SYMBOL	COLOR	DMC	ANCHOR	SYMBOL	COLOR	DMC	ANCHOR
•	White	000	2	◇	Med. Tangerine	741	304
s	Med. Christmas Red	304	1006	≠	Med. Yellow	743	302
L	Lt. Steel Gray	318	399	÷	Lt. Pale Yellow	745	300
4	Dk. Steel Gray	414	235	▲	Dk. Beige Brown	839	360
z	Med. Shell Gray	452	232	‡	Dk. Emerald Green	910	229
♦	Vy. Dk. Blue Green	500	683	△	Rose Brown	3064	883
×	Dk. Blue Green	501	878	3	Vy. Dk. Pink Beige	3773	1008
u	Blue Green	502	877	£	Terra Cotta	3830	5975

BLENDED STITCHES

SYMBOL	COLOR	DMC	ANCHOR
+{	Pearl Gray (2 str)	415	398
	Silver blending filament (1 str) 001BF	001BF	

BACKSTITCHES

— Black (2 str) - Shop name 310 403
— Lt. Steel Gray 318 399
— Vy. Dk. Blue Green - All trees and borders 500 683
— Dk. Emerald Green (2 str) - Garland around sign 910 229
— Black Brown - All else 3371 382

— Black (2 str) - Shop name 310 403
— Lt. Steel Gray - All snow and ice 318 399

FRENCH KNOTS

• Black (2 str) - Nails on gutter 310 403

Fabric: 14-count natural Aida
Stitch Count: 140 wide × 170 high

special instructions

Refer to pages 94-95 for general stitching information. Use 2 strands of floss for cross stitches and 1 strand for backstitches, unless otherwise noted.

FABRIC

Counted cross stitch uses fabrics that are evenly woven—the number of horizontal threads per inch (2.5 cm) should match the number of vertical threads per inch. If the fabric is not evenly woven, the design will be distorted. The Department 56 Village cross stitched models in this book were done on Charles Craft 14-count natural Aida, which means there are 14 threads to an inch (2.5 cm). Add at least 3" (7.5 cm) to all sides of the finished design size to determine the actual amount of fabric you will need. For example, if the finished design size is 10¼" × 12½" (26.1 × 31.8 cm) you will need to cut 16¼" × 18½" (41.1 × 47.3 cm).

Any even-weave fabric with a 14 count can be substituted for Aida. In addition, a 28-count fabric could be substituted, if you stitch over two threads instead of one. You can also change the size of a design by using a different-count fabric. This will change the amount of fabric needed, as well as the amount of floss.

To determine how much substitute fabric you will need, divide the stitch count width and height by the desired thread count. For example, if the stitch count is 143 × 176 squares, the finished design size will be 13" × 16" (33 × 40.5 cm) on 11-count fabric. This was determined by dividing 143 and 176 by 11. For 18-count fabric, dividing 143 and 176 by 18 means the design will be smaller, about 8" × 9¾" (20.5 × 25 cm).

The cut edges of even-weave fabrics will ravel, and they should be finished before stitching. Bind the edges with masking tape, apply liquid fray preventer, or sew the edges with a zigzag or overcast stitch. The last method is recommended for projects of heirloom quality. Use an embroidery hoop or scroll frame while stitching to keep the fabric taut.

FLOSS

Two brands of floss are listed on the Color Key. It is recommended that you do not mix floss brands. The Department 56 Village cross stitched models in this book were done with DMC floss.

Cut floss strands about 18" (46 cm). Separate all floss strands, and then put the appropriate number back together. To separate floss strands, begin pulling the strands apart in the center of the

18" (46 cm) length and work out to the ends. Use two strands of floss for the cross stitches, and one strand for backstitches, unless noted differently.

FINDING THE CENTER OF THE FABRIC

All designs are centered on the fabric; to find the center, fold the fabric in half from top to bottom and then in half again from side to side. Gently pinch the fabric along the folds to make slight creases, which will intersect at the center point. Mark the center with a straight pin or basting lines.

DESIGN CHART

Each square on a chart represents one cross stitch, and each cross stitch is worked over one thread. The symbols on the chart represent the color of a stitch. The Color Key indicates which color the symbol represents. Special instructions for each design, such as backstitch colors and special stitches, are noted within the Color Key.

BEGINNING STITCHING

Cut the appropriate color floss, separate the strands and put two of them back together. Thread floss through the needle, and bring the needle up through the fabric from the back side. Leave a small tail of floss, and hold it in place as you work the first few stitches over the tail. Do not knot the floss.

Kreinik® blending filaments are used to achieve special effects, such as metallic finishes. Blending filaments and embroidery floss have different elasticities. To deal with that difference, it is recommended that you knot the blending filament on the needle. Pass a loop of blending filament through the eye of the needle; then insert the point of the needle through the loop. Tighten the loop at the end of the eye. Thread other floss through the eye of the needle to begin stitching (PHOTO 1).

PHOTO 1

CROSS STITCHING

There are four small open spaces surrounding each fabric thread. To make a single cross stitch, bring the needle up at 1 and down at 2, up at 3 and down at 4 (PHOTO 2). To make several cross stitches in a row, work the first half of the stitches in one direction, and the other half in the opposite direction. For an expert finish, the top stitch in all cross stitches should go in the same direction. Make certain that your stitches are taut, but not so tight that the fabric threads are pulled out of shape. Work rows in a downward direction; this keeps stitches smoother. You can turn the fabric and the chart upside down, if necessary.

PHOTO 2

Complete all the cross stitches first, working from the center outward; then follow the special instructions to complete the design with details such as backstitching or special stitches. In these designs, ¼ and ¾ cross stitches are used to make fine details, curved lines and special shading effects (PHOTO 3). A ¼ cross stitch is represented on the chart with a smaller symbol from the Color Key in the corner needed. A ¾ cross stitch is represented with a small symbol in the corner plus a diagonal line. Each of these stitches can go in any of four different directions, depending on the side of the diagonal line and the corner on which the symbol is printed. For the ¾ cross stitch, stitch a ¼ cross stitch of floss color, and the ½ cross stitch in the same color. If the ¾ cross

PHOTO 3

stitch has a backstitch across it, that will be the ½ cross stitch.

SPECIAL STITCHES

Detail and definition are created by outlining with the backstitch (PHOTO 4). French knots add punctuation on signs or other highlights, and are done as shown. Using the number of strands indicated, bring the needle up through the fabric hole. Holding the thread taut, wrap the needle by passing the thread over and under in a spiral motion. Holding the remaining thread firmly, insert the needle into the fabric close to the hole where it started. Tug the thread until excess is pulled through.

PHOTO 4

ENDING STITCHING

When you have completed all adjoining stitches with one color, fasten the floss and begin with the next color as described above. To fasten the floss, bring the floss to the back side and run under at least four stitches to hold it in place. Clip the floss close to the fabric; do not knot (PHOTO 5).

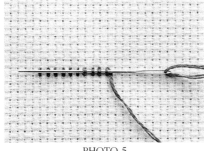

PHOTO 5

Even though the same color of floss is used on another part of the design, you should fasten the floss and start again in the new spot. Floss that is run across the back of the fabric from one spot to another will often show through on the front.

FINISHING

Lay the stitched piece facedown on a terry-cloth towel. Dampen it slightly if it is badly creased. Press from the wrong side with a medium-hot iron. If the piece has become soiled, it can be soaked in cold water with a mild detergent. However, you should test the floss for colorfastness before washing your completed piece. Do not wring out the fabric. Roll it in terry-cloth towels to remove excess moisture, and press on the wrong side until it is dry.

STRETCHING AND MOUNTING

Matting and framing your Department 56 design will offer protection to the piece. A single mat is usually all that is needed to raise the glass in a frame above the surface of the stitching. Spacers should be used if framing is done without a mat. For the best protection of all projects, use acid-free foam-core boards and mat boards.

To frame the stitched design without any wrinkles or bubbles, the fabric is stretched around a foam-core mounting board. For easy mounting, 3" (7.5 cm) of fabric were allowed on each side of the design. If necessary, fabric strips can be stitched to the sides of the design if you were not able to work with a piece of fabric that size.

Cut the acid-free foam-core mounting board with a utility knife and straightedge at least 2" (5 cm) larger than the image opening of the mat. This allows you to adjust the position of the mounting board behind the mat. If a mat is not desired, the mounting board is cut to fit the frame opening.

Center the design right side up over foam-core board. Insert a T-pin through the fabric and into the edge of the foam core, at the center of one side. Aligning the grain of the fabric with the edge of the board, pin the fabric at each corner of that side, pulling the fabric taut between pins. Repeat to stretch and

PHOTO 6

pin the fabric to the adjacent side, then the remaining sides (PHOTO 6).

Continue to stretch and pin the fabric between T-pins, completing one side at a time and spacing T-pins every ½" (1.3 cm). Recheck that the design is straight; repin as necessary. Check that the fabric is taut by smoothing a finger across the piece; you should not be able to push any excess fabric. Repin the fabric as necessary (PHOTO 7).

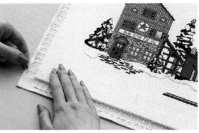

PHOTO 7

Sequin pins are recommended to secure the fabric to the mounting board; they will not damage the fabric and can be removed if you wish to use the piece for another project at a later date. Insert the sequin pins into the edge of the board at ¼" (6 mm) intervals, removing the T-pins.

Fold in the excess fabric at the corners; secure with hand stitching. Your stretched cross stitch design is now ready to be matted or framed (PHOTO 8).

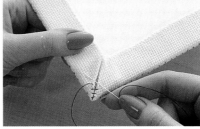

PHOTO 8

Credits

CY DECOSSE INCORPORATED
President/COO: Nino Tarantino
Executive V.P./Editor-in-Chief: William B. Jones
Chairman Emeritus: Cy DeCosse

Group Executive Editor: Zoe A. Graul
Associate Creative Director: Lisa Rosenthal
Art Director: Stephanie Michaud
Project Manager: Amy Berndt
Sample Production Manager: Carol Olson
Technical Editor: Deborah Howe
Editor: Janice Cauley
Contributing Writer: Barbara Lund
Contributing Artists: Eileen Bovard, Gerald Goodge
Project Stylist: Christine Jahns
Technical Photo Stylists: Bridget Haugh, Coralie Sathre,
 Nancy Sundeen
Styling Director: Bobbette Destiche
Prop Stylists: Elizabeth Emmons, Christine Jahns, Michele Joy
Food Stylists: Elizabeth Emmons, Nancy Johnson
Artisans: Arlene Dohrman, Phyllis Galbraith, Carol Pilot,
 Michelle Skudlarek, Sue Walentiny
Vice President of Photography & Production: Jim Bindas
Creative Photo Coordinator: Cathleen Shannon
Studio Manager: Marcia Chambers
Photographers: Mark Macemon, Michael Parker,
 Steve Smith
Print Production Manager: Mary Ann Knox
Senior Desktop Publishing Specialist: Joe Fahey
Desktop Publishing Specialist: Laurie Kristensen
Production Staff: Kathlynn Henthorne, Laura Hokkanen,

Tom Hoops, Mark Jacobson, Jeanette Moss, Mike Schauer,
 Michael Sipe, Brent Thomas, Greg Wallace, Kay Wethern
Shop Supervisor: Phil Juntti
Scenic Carpenters: Troy Johnson, Rob Johnstone, John Nadeau
Contributors: Crescent Matboard Co., The DMC Corporation,
 EZ International
Pattern Conversions: The Design Connection, Inc.

COWLES
Enthusiast Media

President/COO: Philip L. Penny

Printed on American paper by:
 R. R. Donnelley & Sons Co. (0796)
99 98 97 96 / 5 4 3 2 1

Cy DeCosse Incorporated offers a variety of how-to books.
For information write:
 Cy DeCosse Subscriber Books
 5900 Green Oak Drive
 Minnetonka, MN 55343

Also available from The Heritage Village Collection® cross stitch pattern books:
The Dickens' Village Series®, The North Pole© Series and The Christmas in the City® Series.

The designs in this book are brought to life in Department 56®, Inc.'s New England Village® Series
of handcrafted, lighted porcelain houses, buildings and coordinated accessories.

The Finished Design Size is an actual measurement of the Department 56® Village cross stitched models
featured in this book, and should be used as an approximation. Your Finished Design Size may vary depending
on the type and brand of fabric used, stitching ability or blocking method, along with other factors.

For more information about the New England Village® Series and the entire
Heritage Village Collection® of fine quality porcelain collectibles, or to find the Department 56®, Inc.
authorized village dealer nearest you, contact:

ONE VILLAGE PLACE
6436 CITY WEST PARKWAY
EDEN PRAIRIE, MN 55344

1-800-LIT-TOWN
(548-8696)